A Walk Through the Forest

COPYRIGHT © A BEE'S LIFE PRESS ALL RIGHTS RESERVED

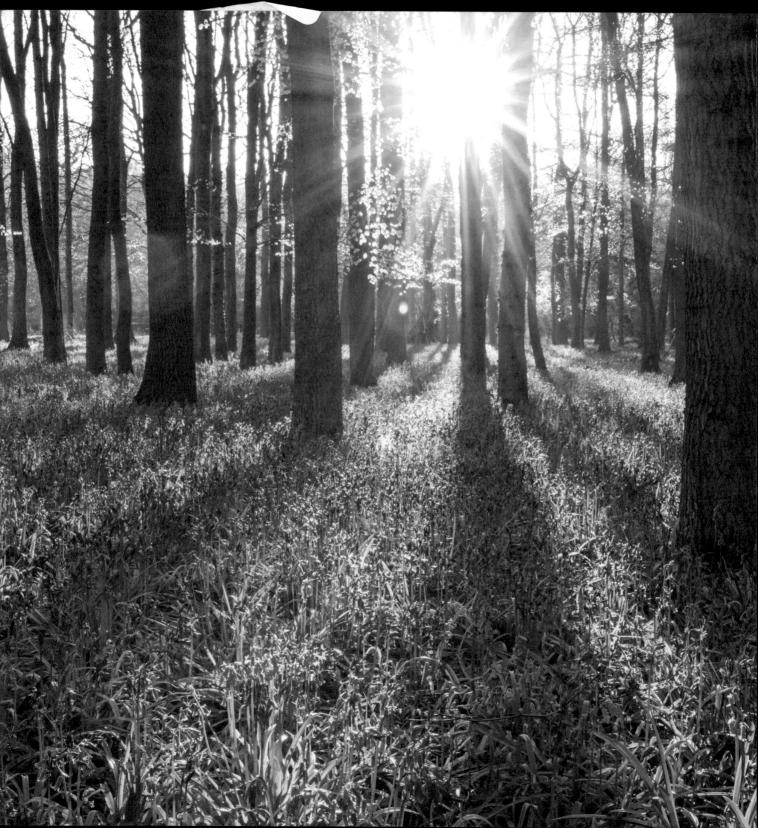

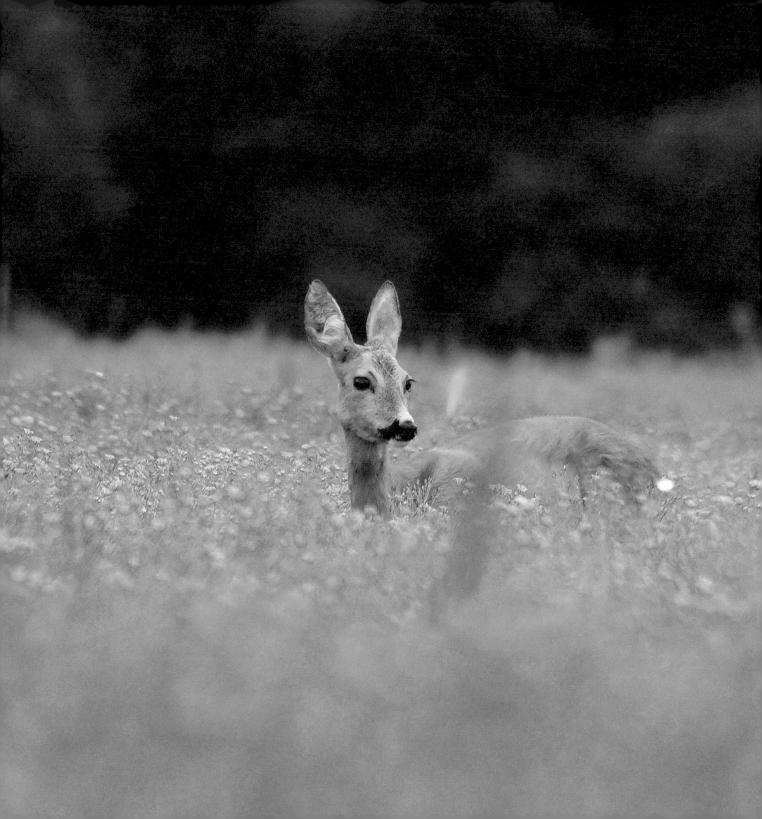

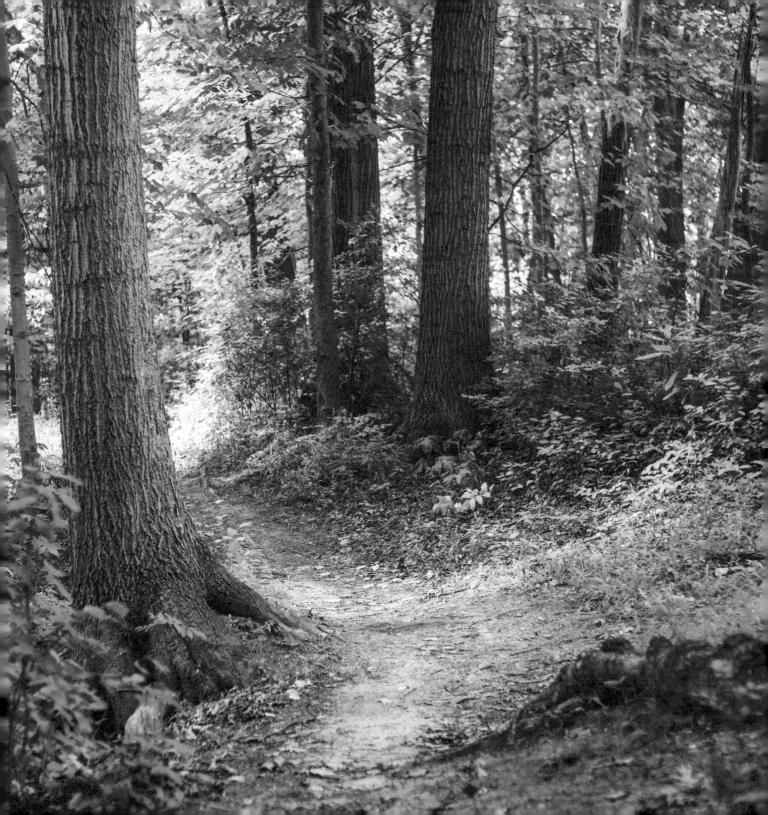

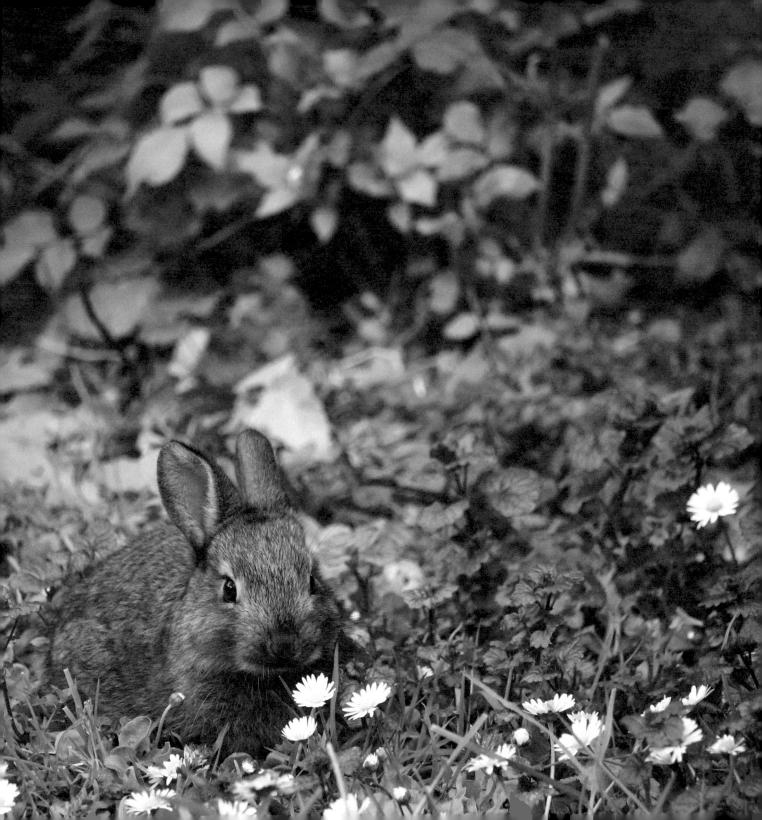

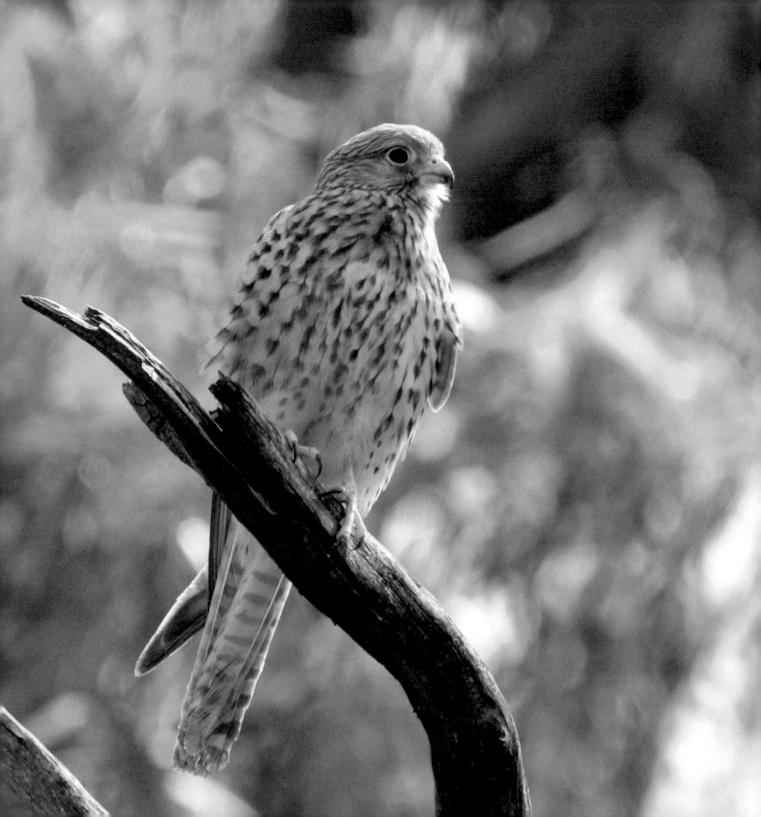

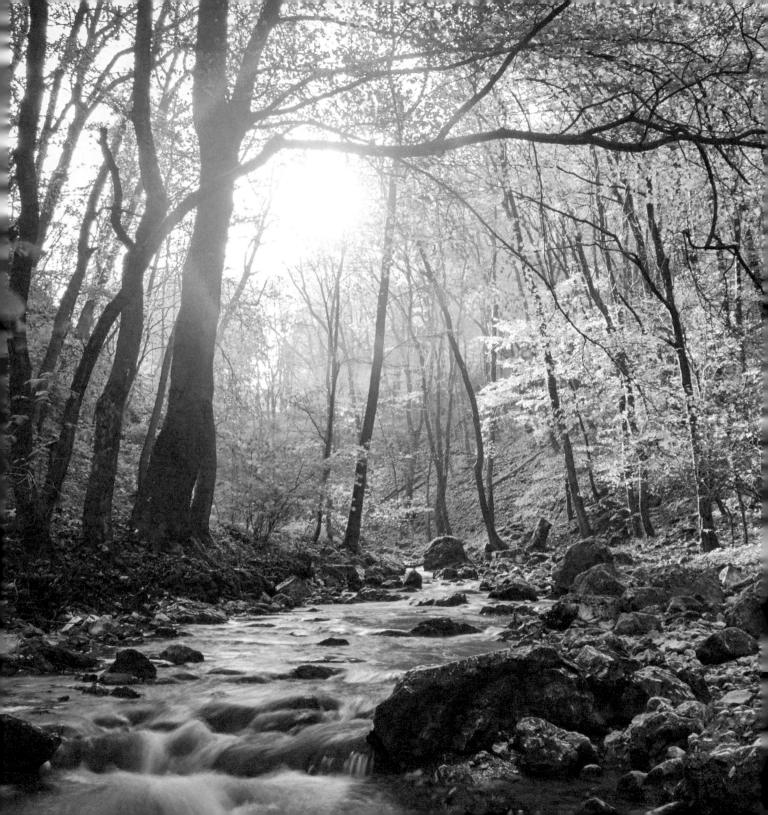

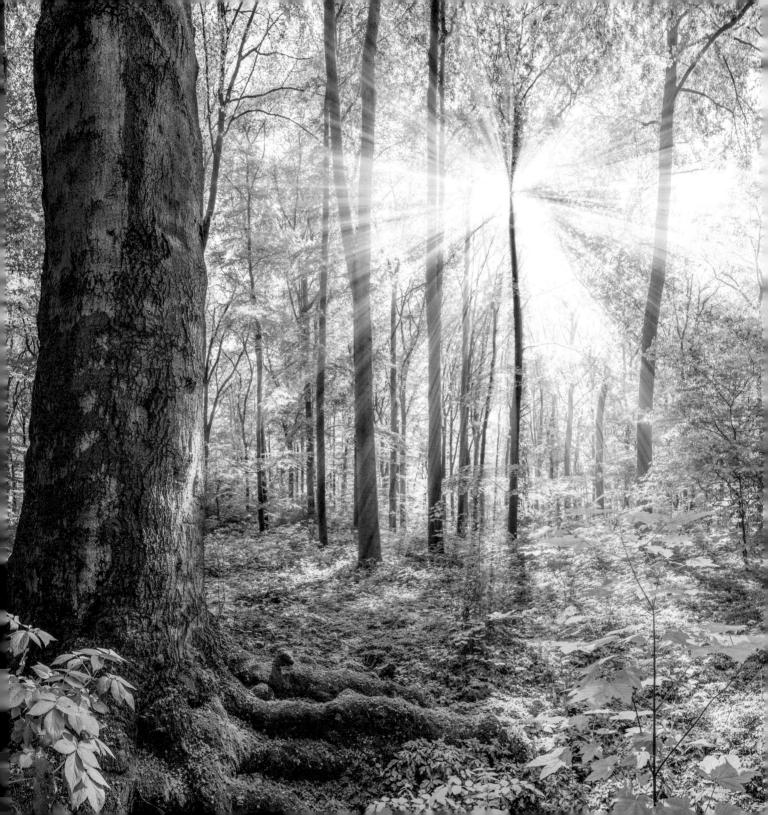

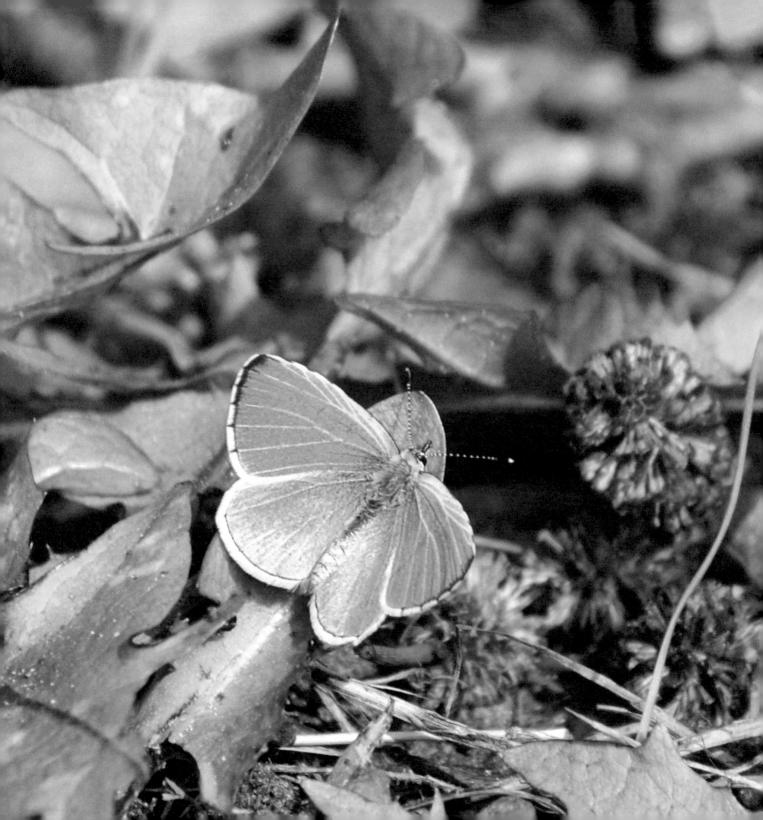

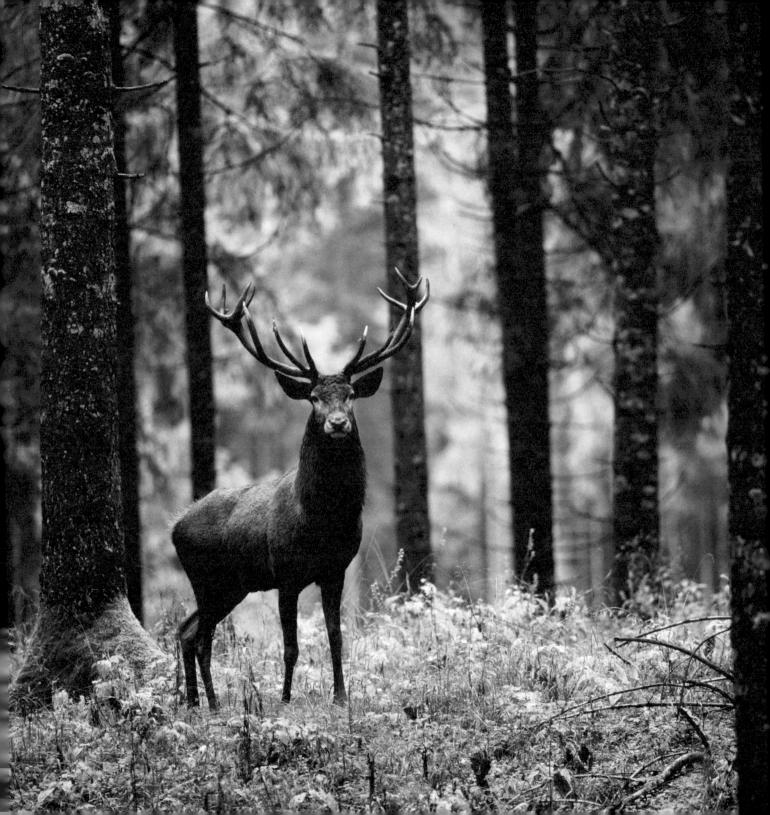

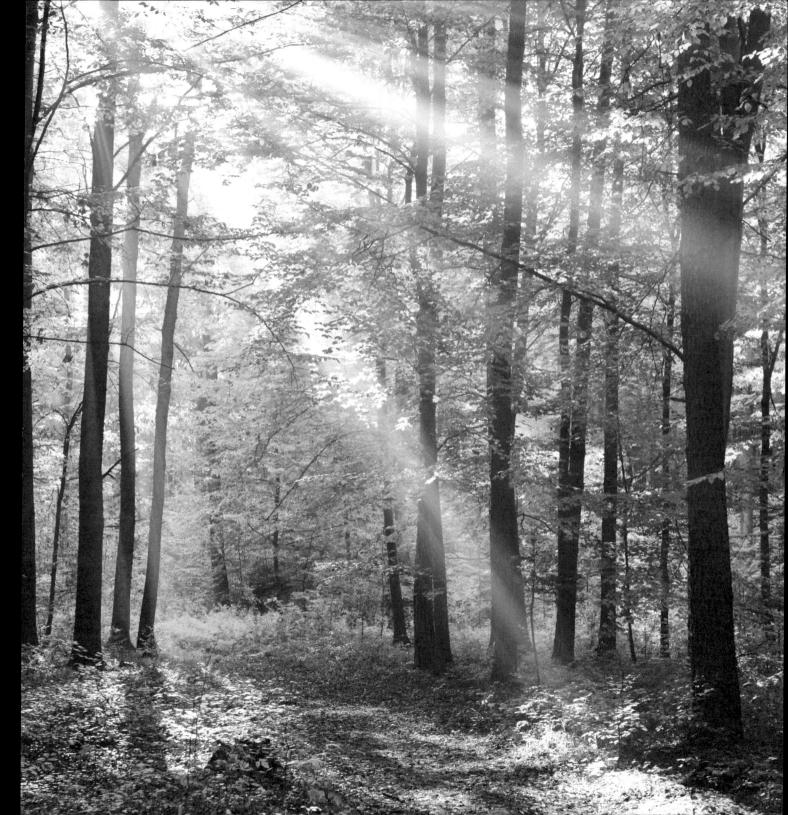

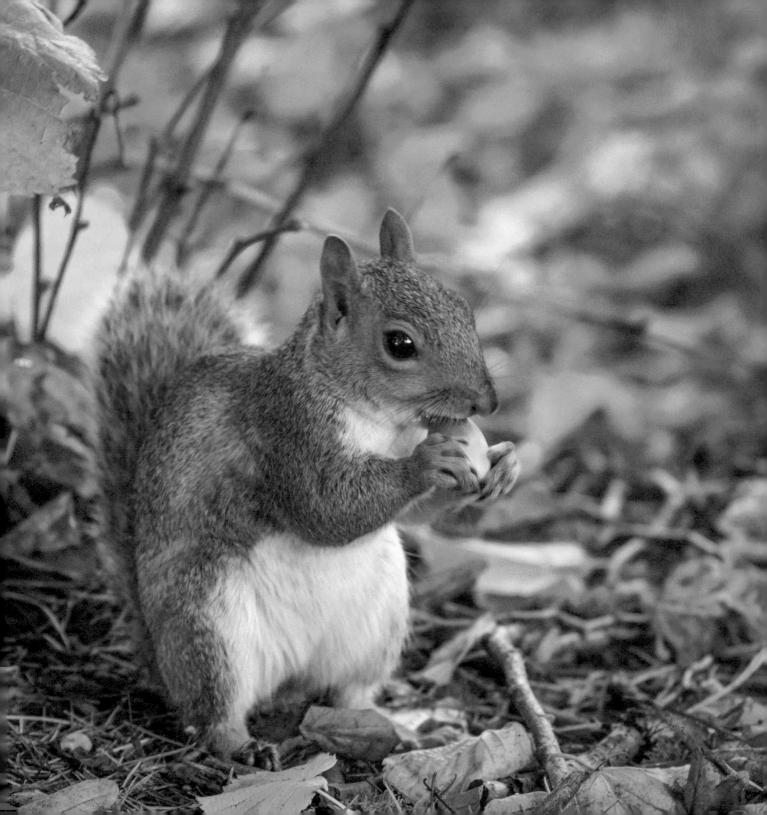

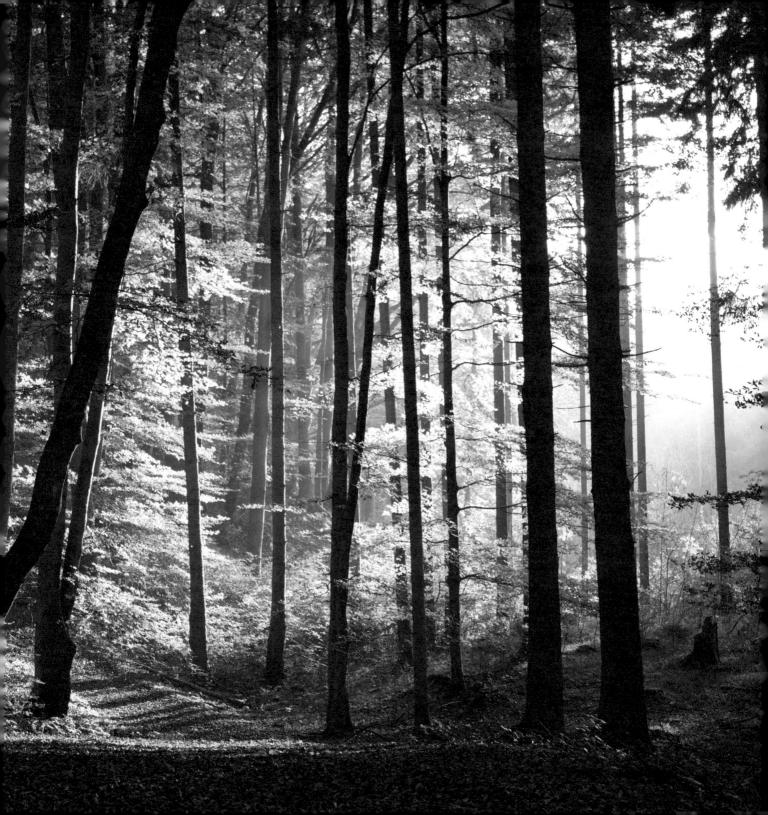

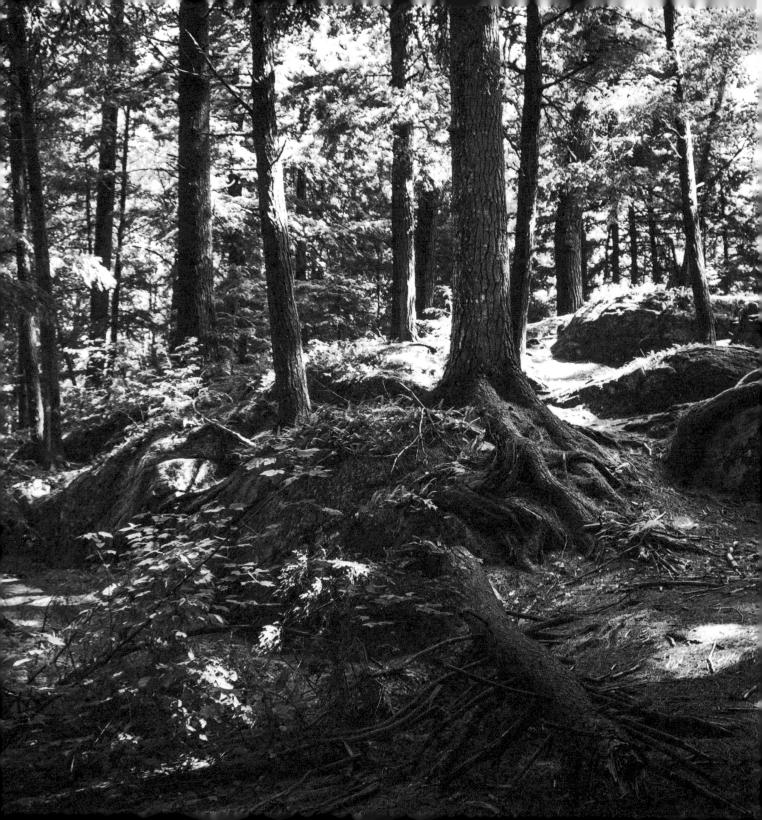

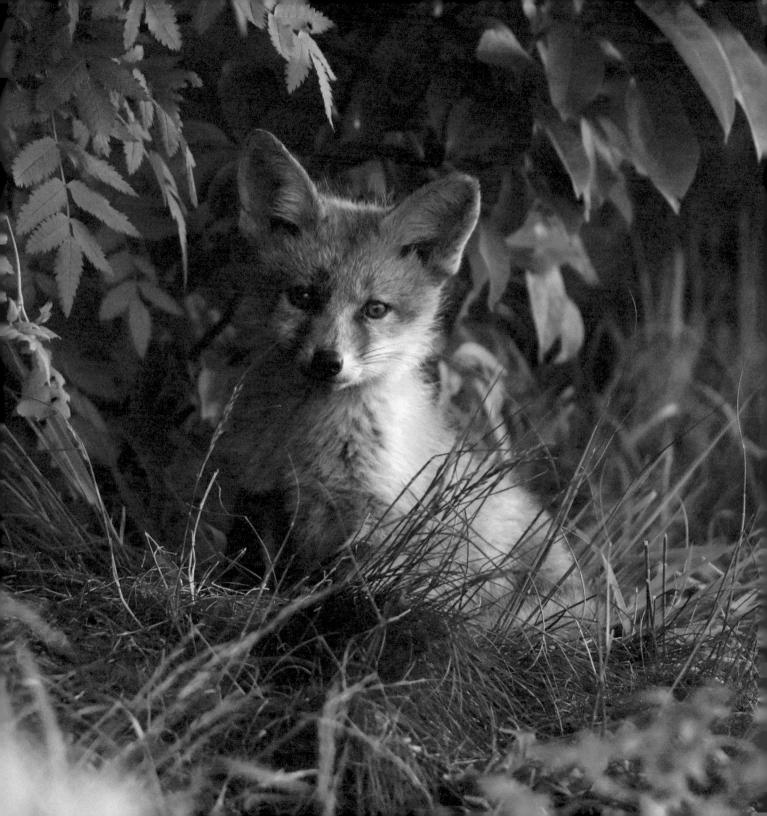

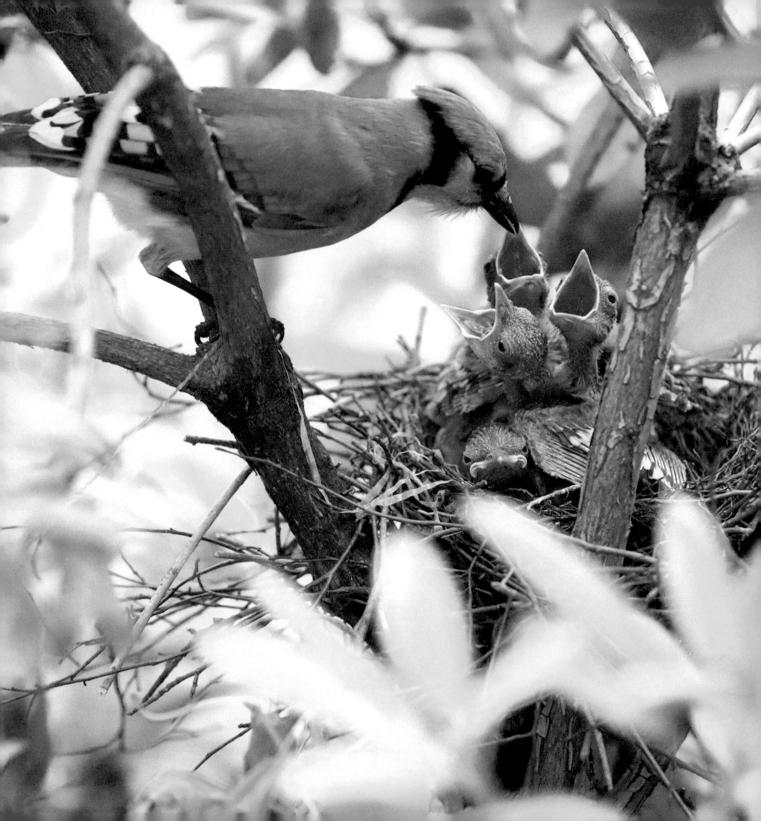

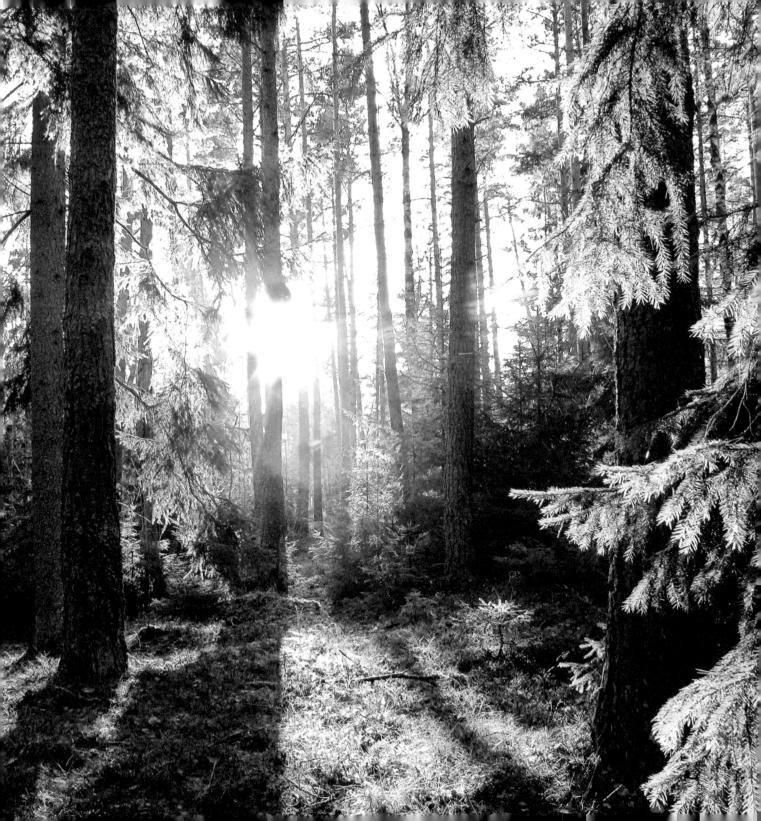

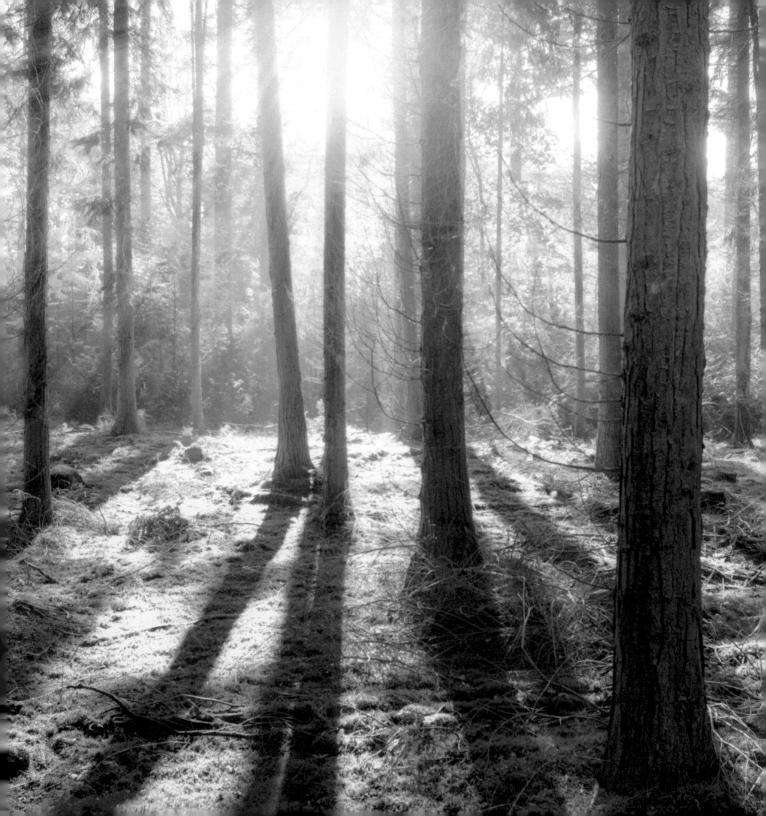

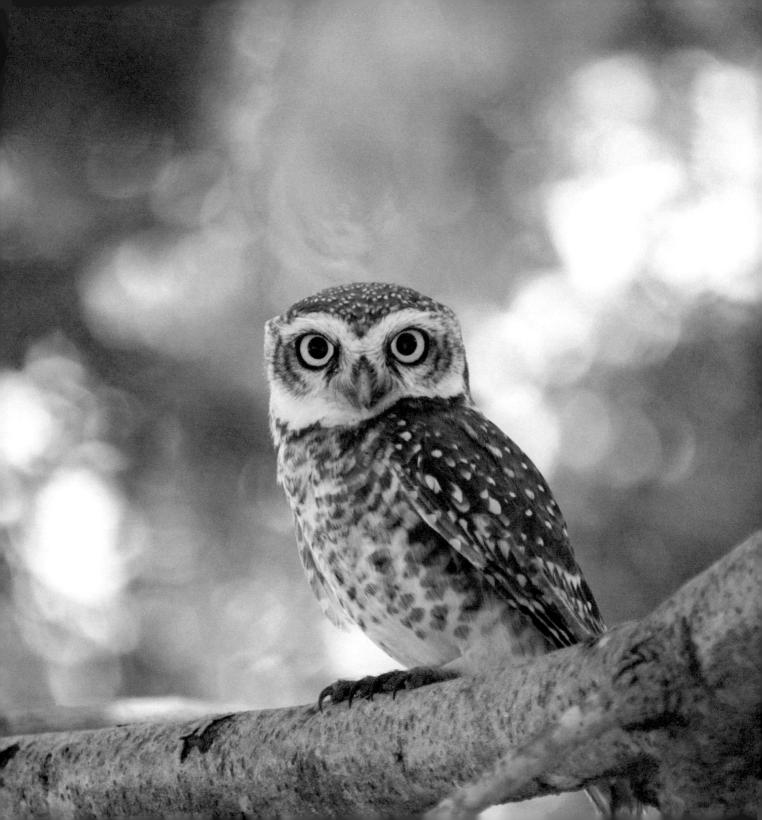

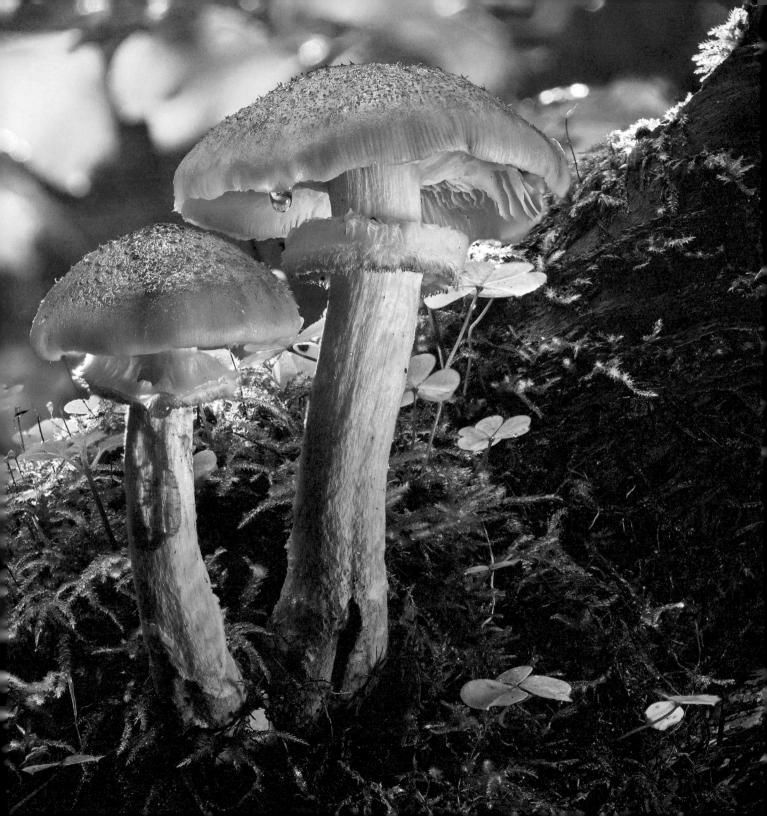

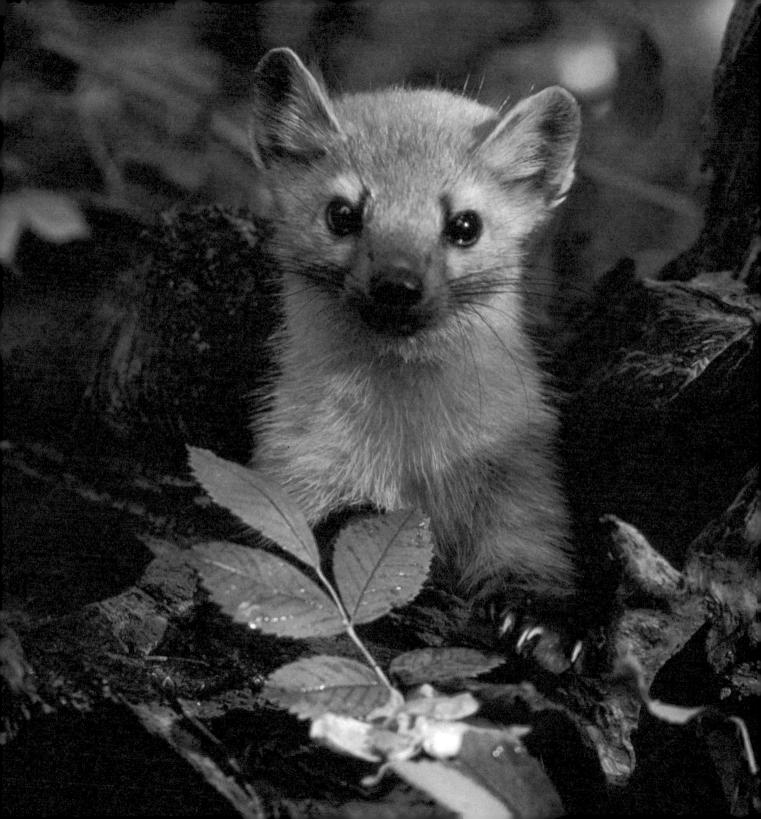

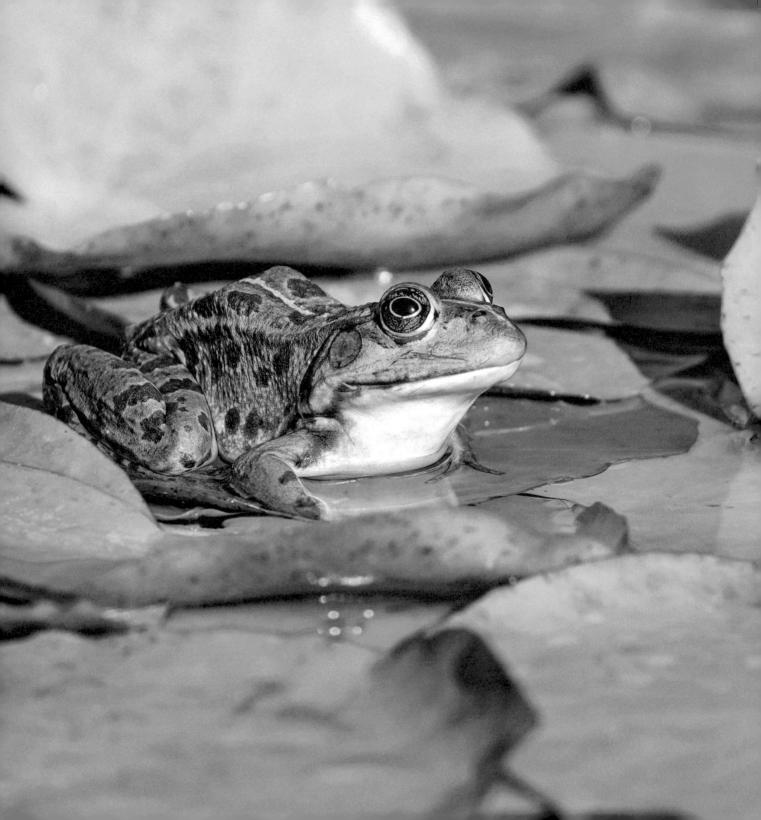

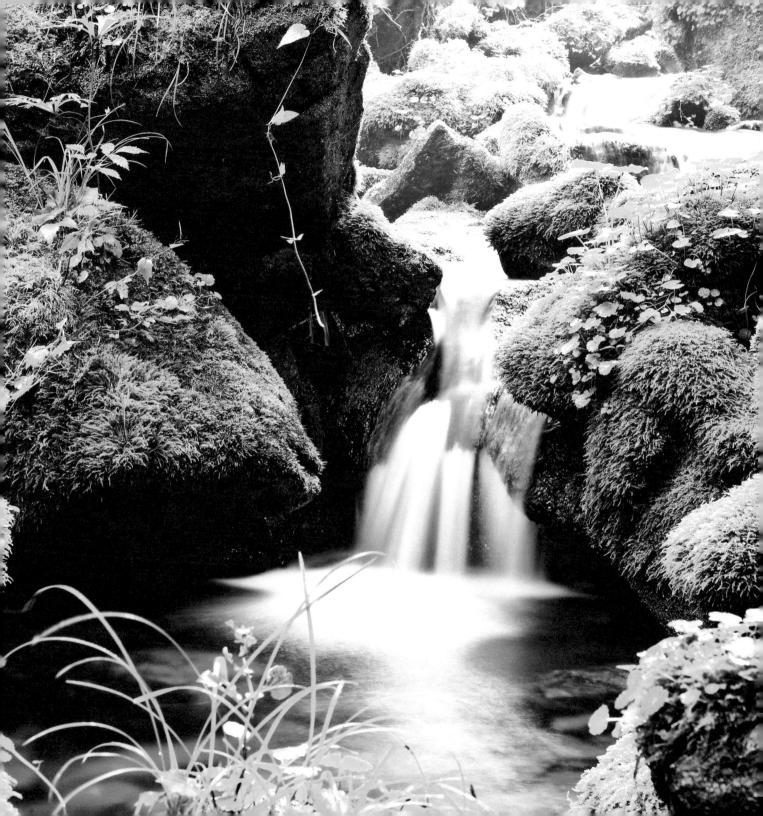

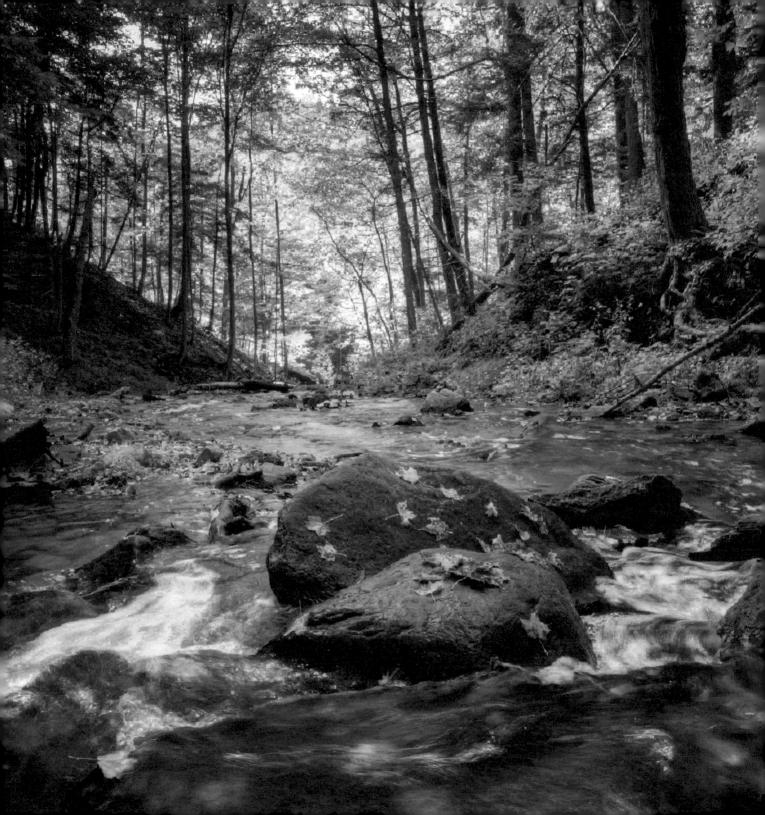

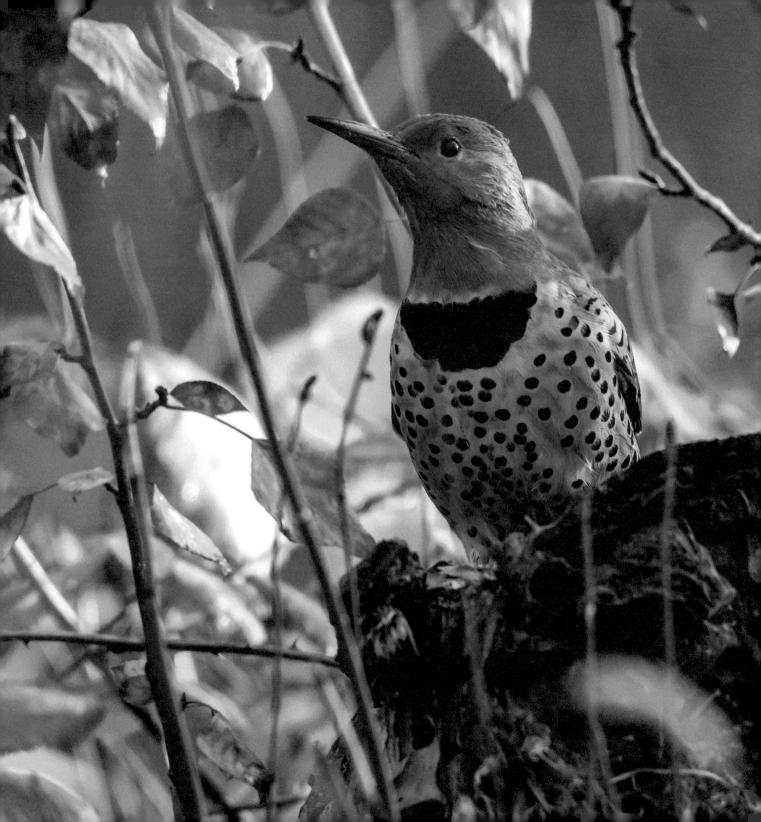

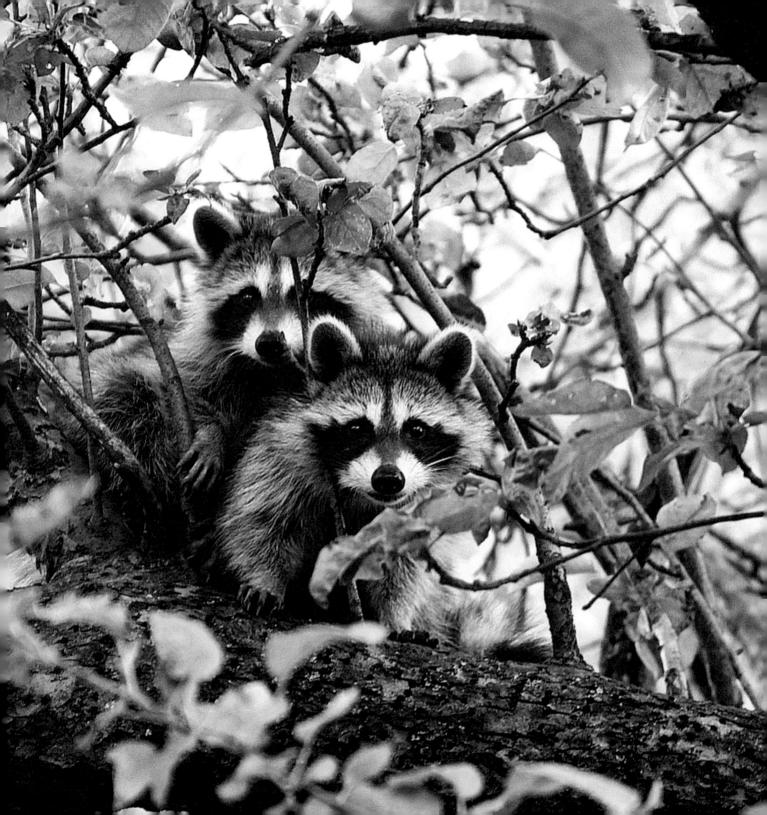

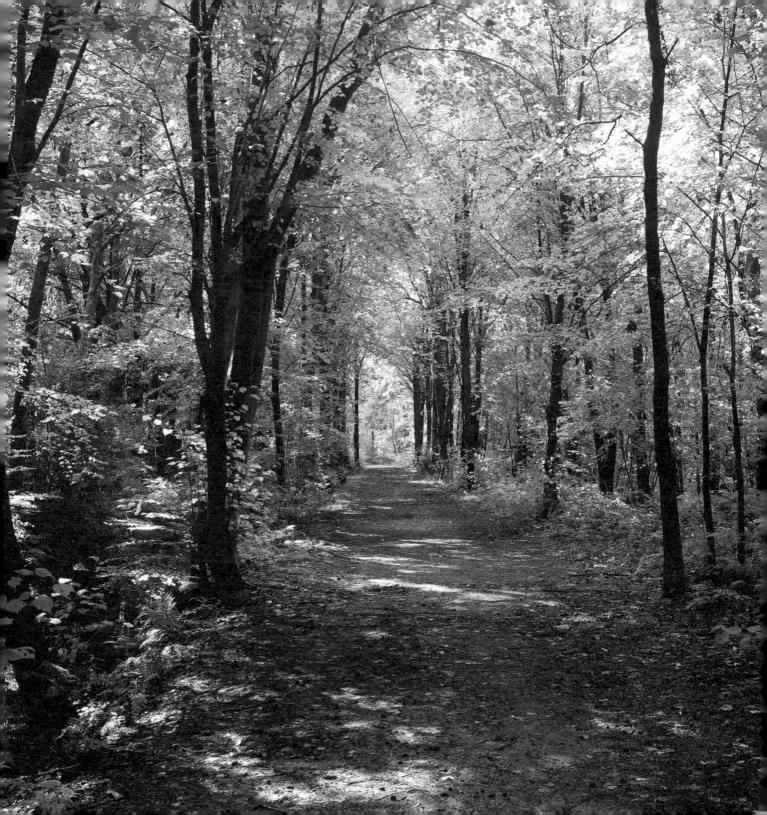

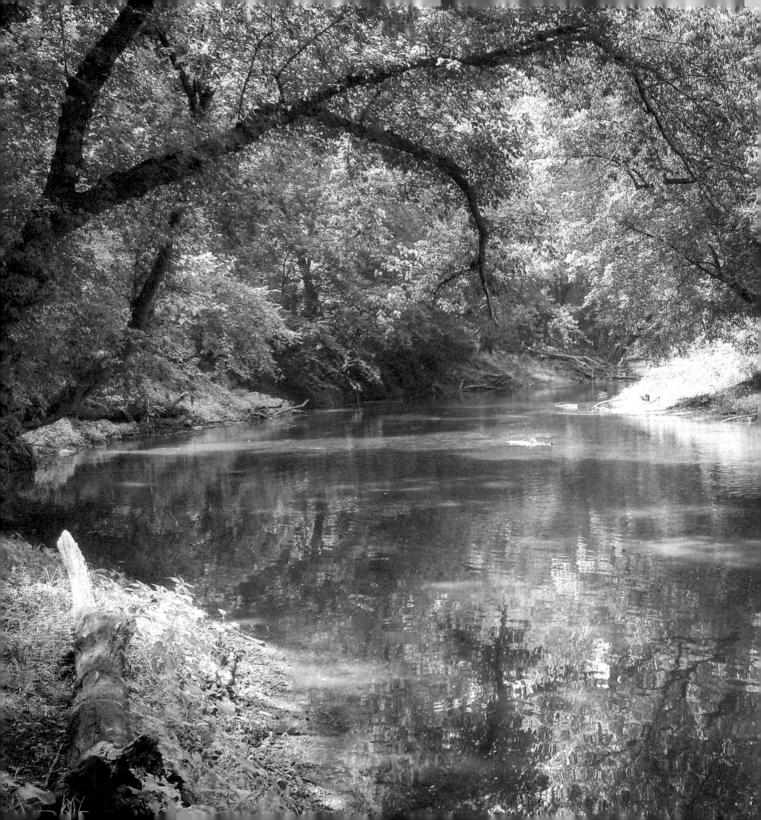

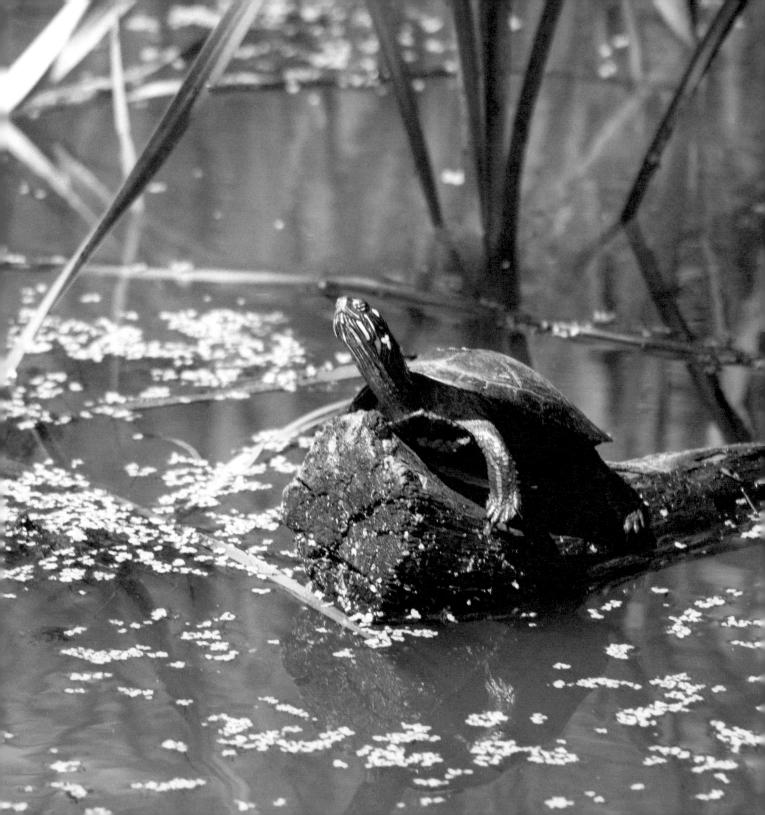

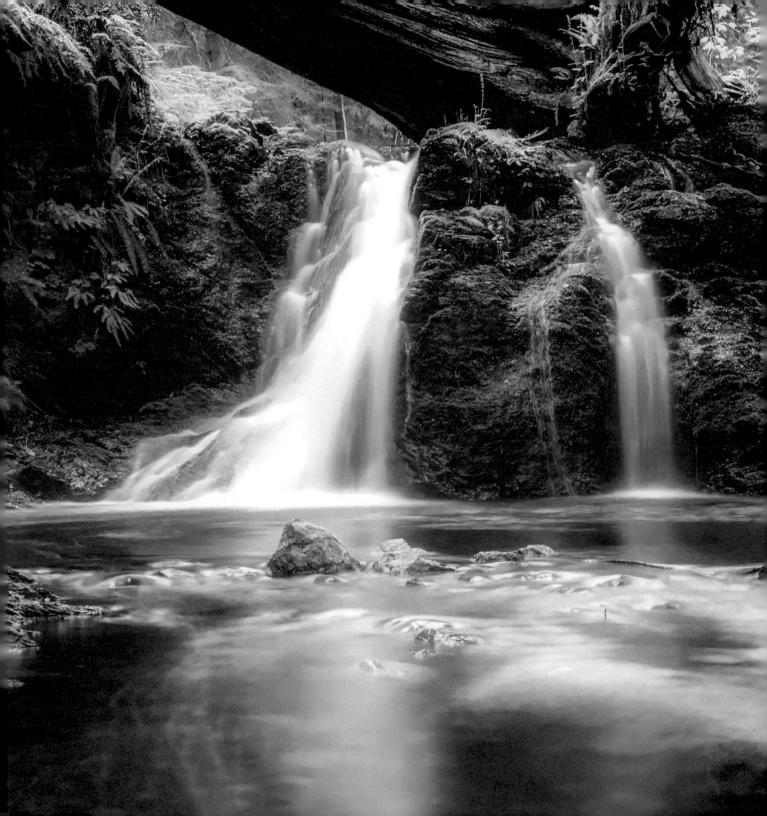

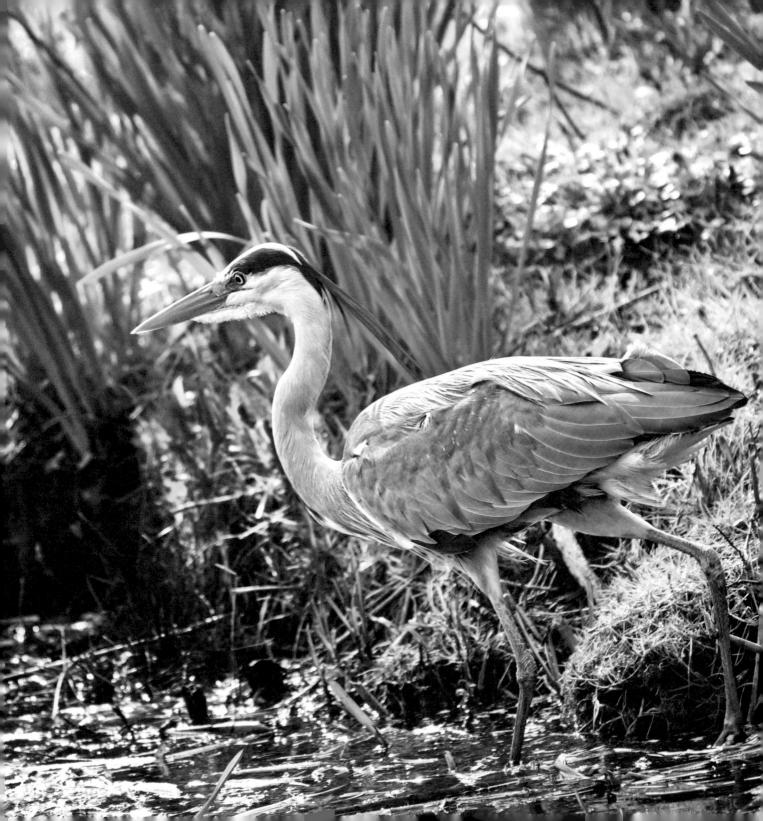

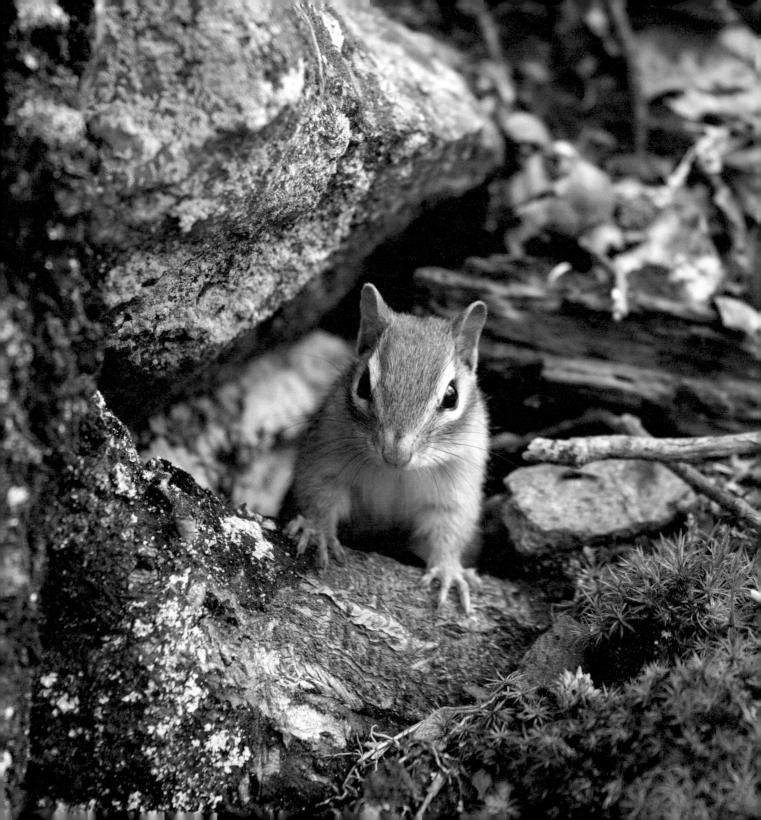

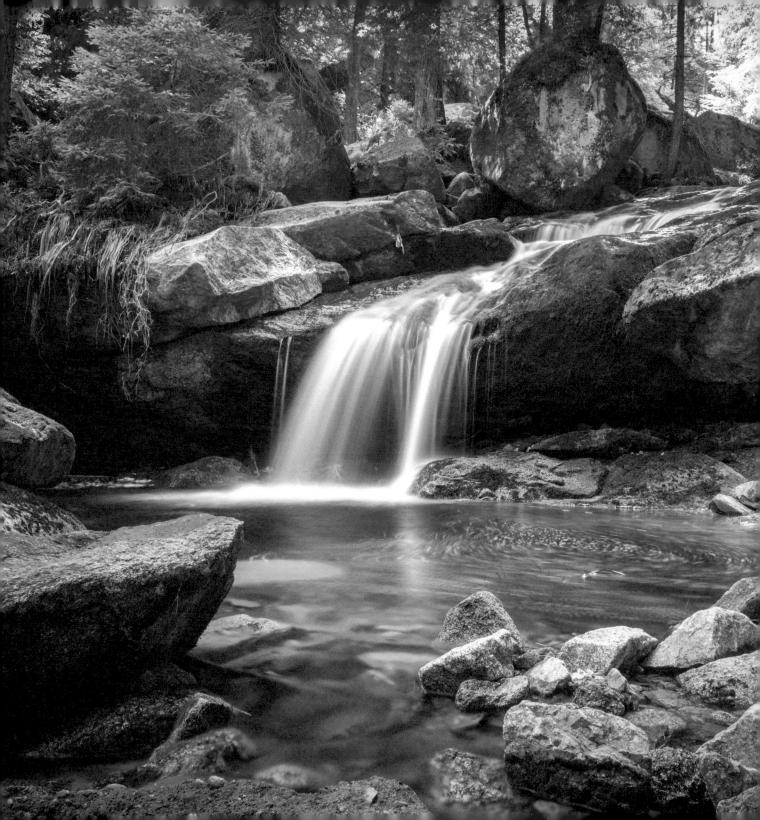

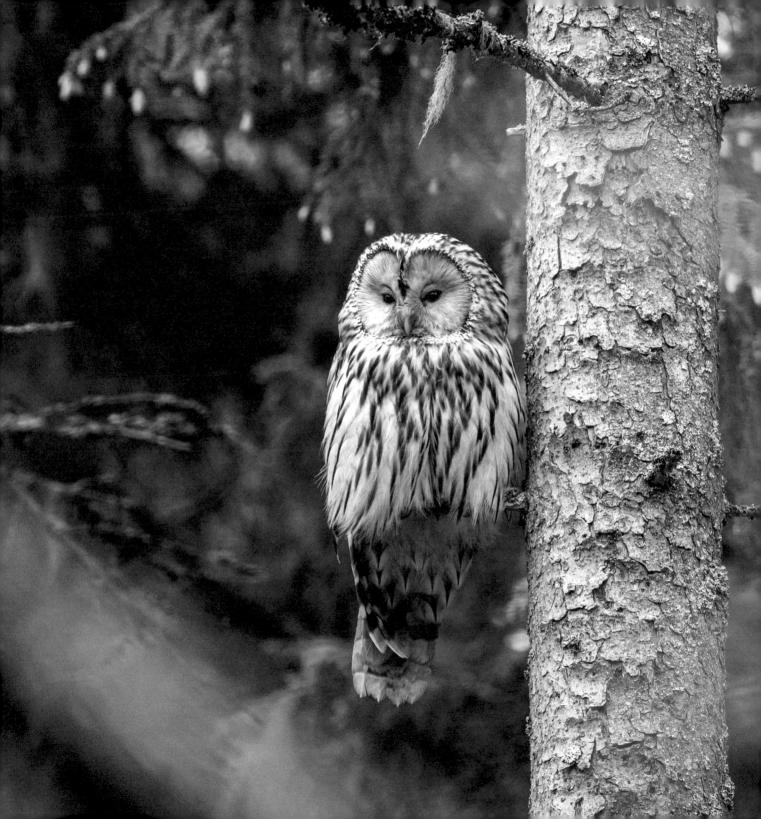

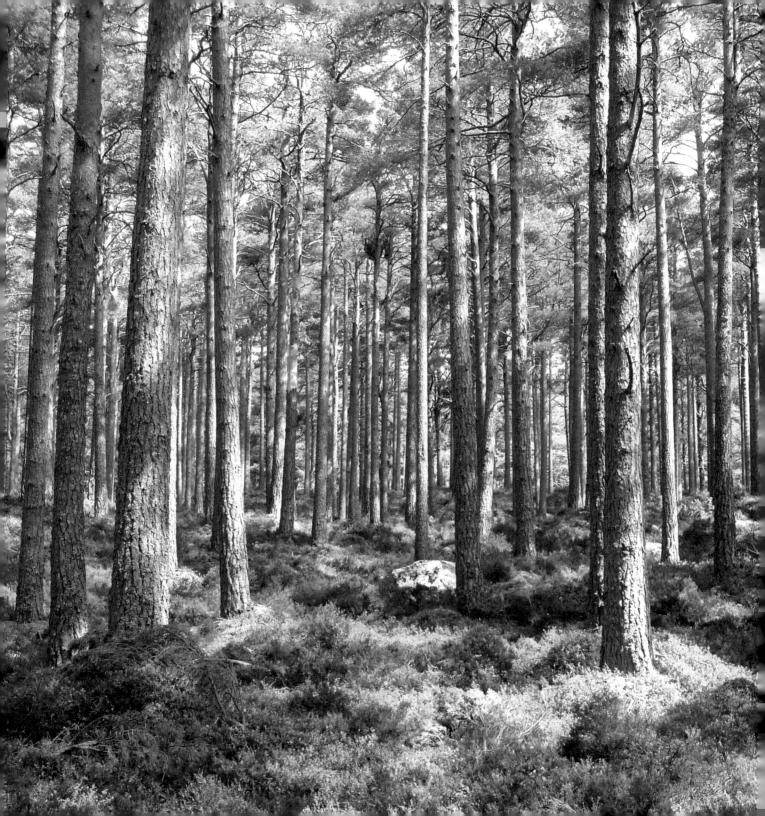

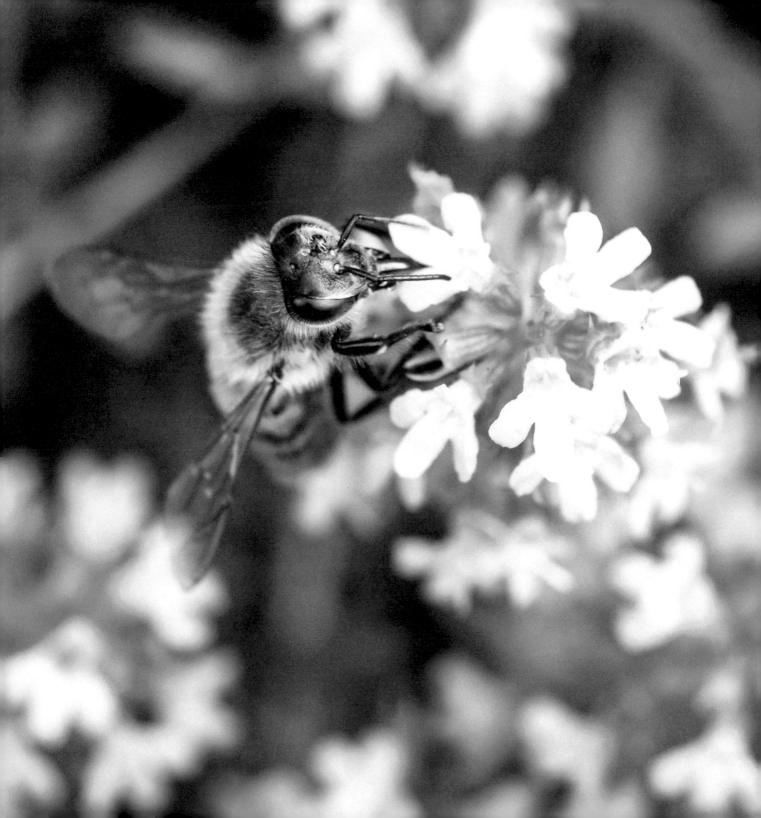

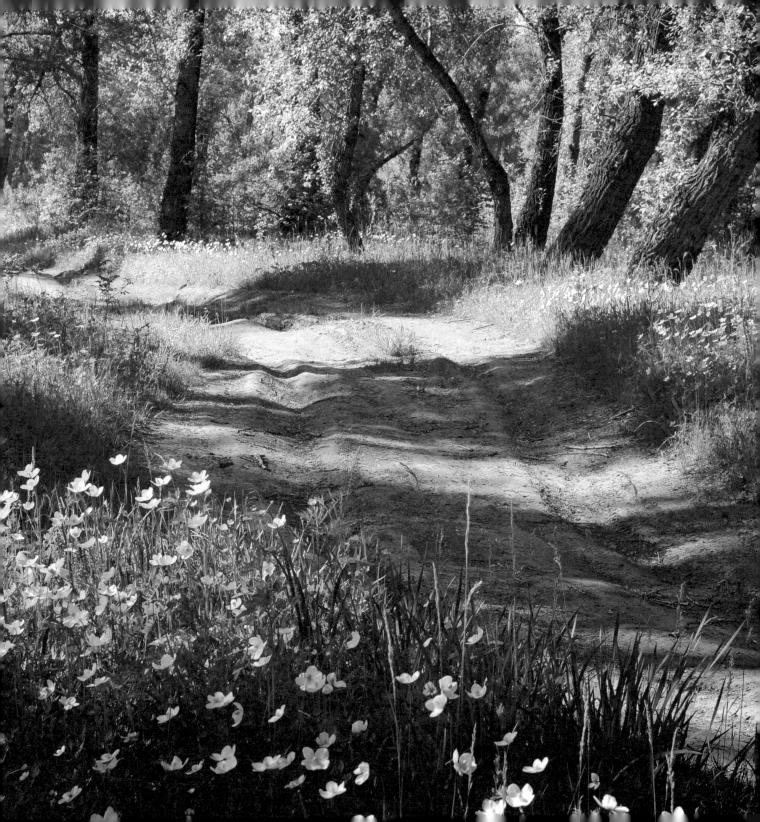

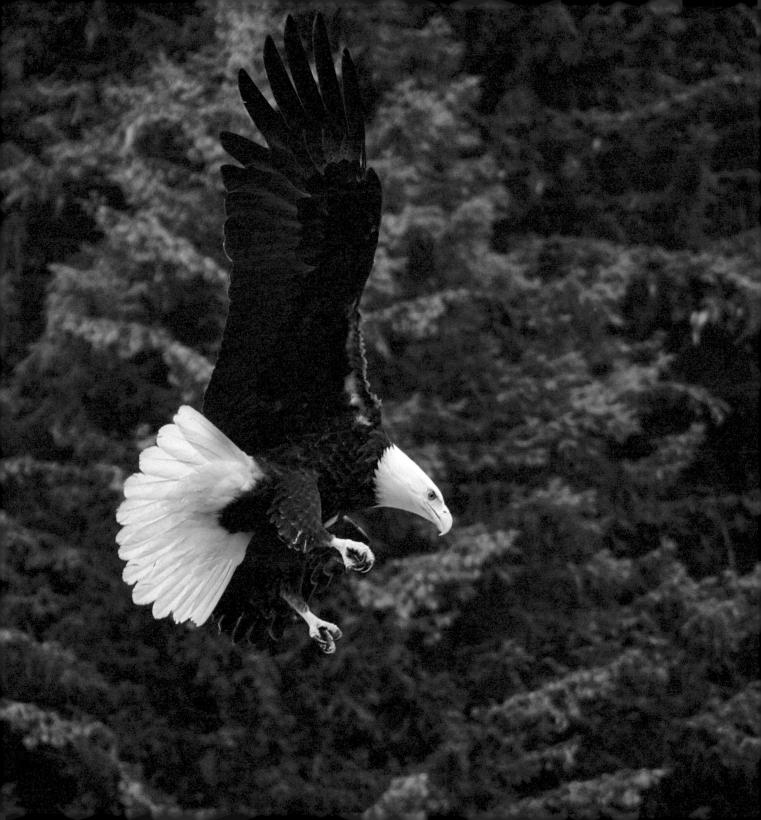

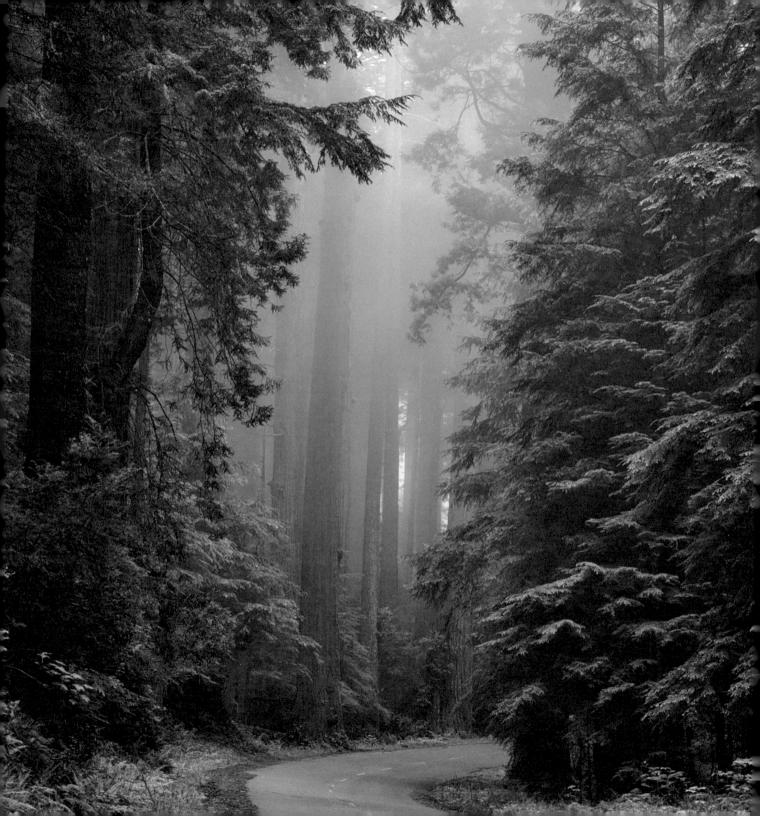

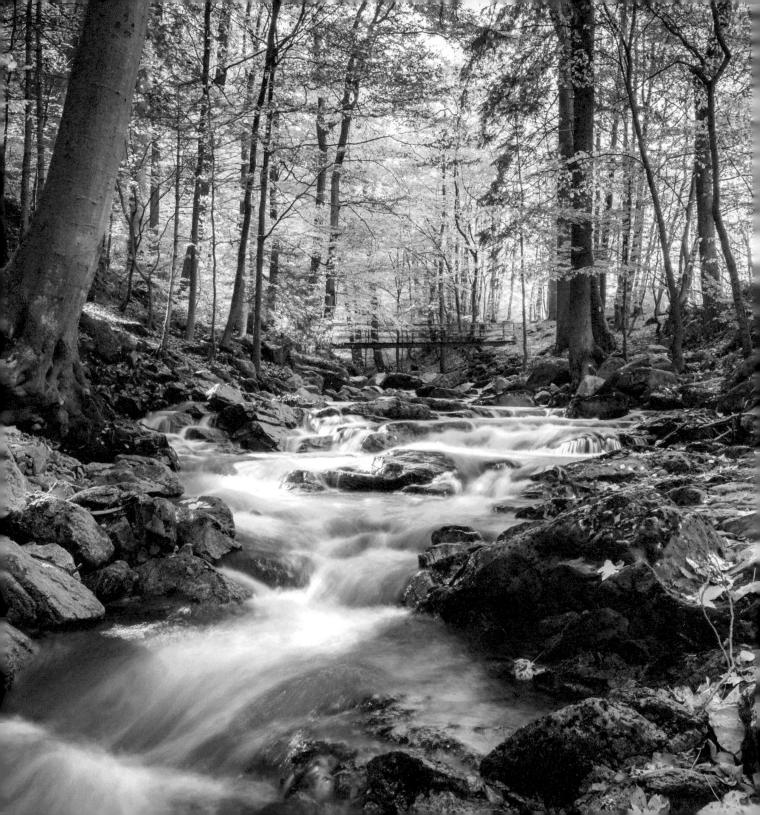

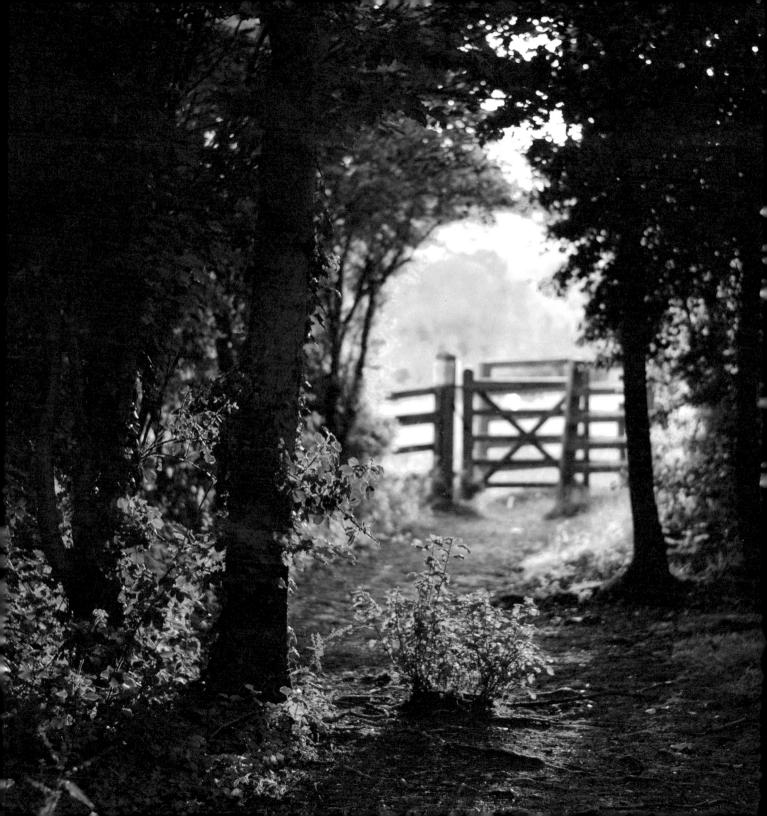

Made in United States Troutdale, OR 12/26/2024

27298222B00026